THIS BOOK IS LITERALLY JUST PICTURES OF TINY ANIMALS THAT WILL MAKE YOU SMILE

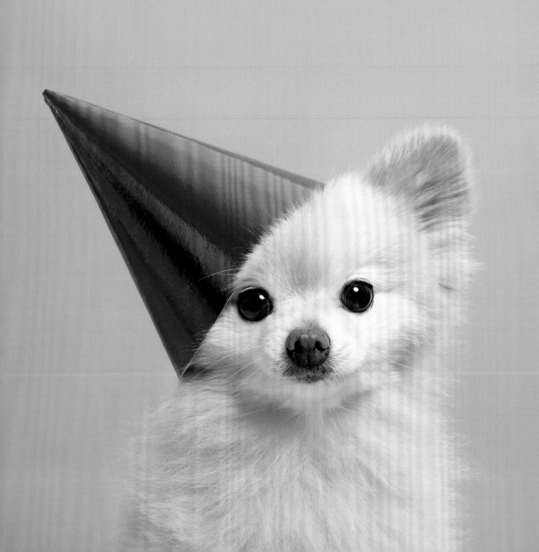

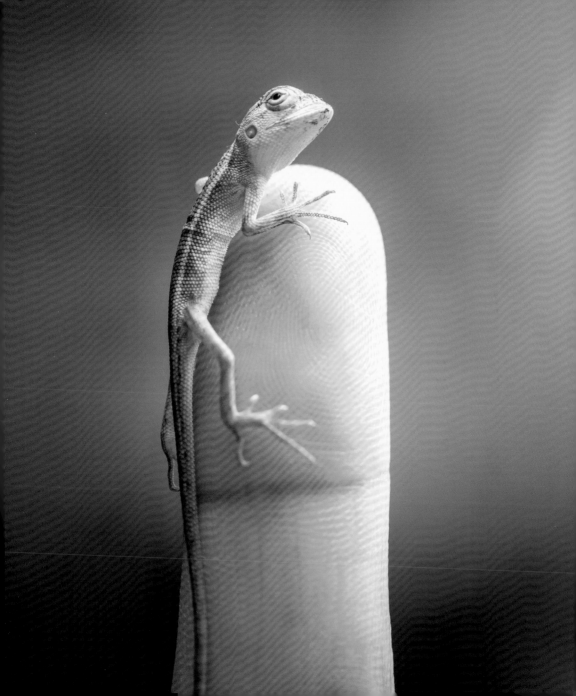

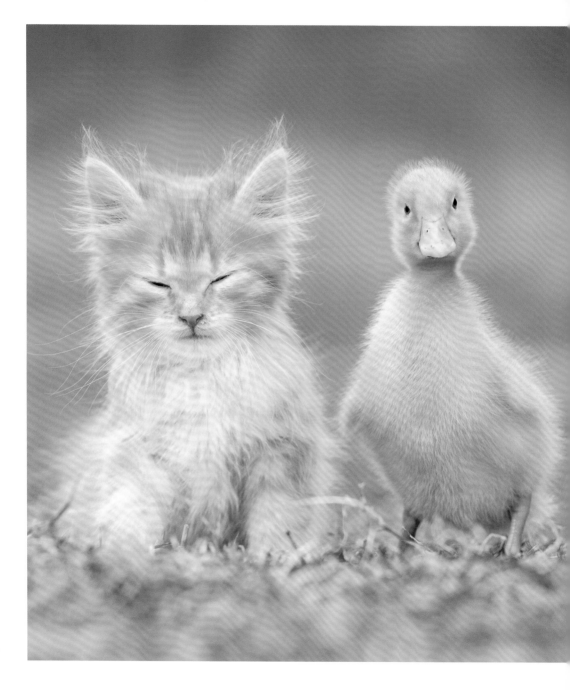

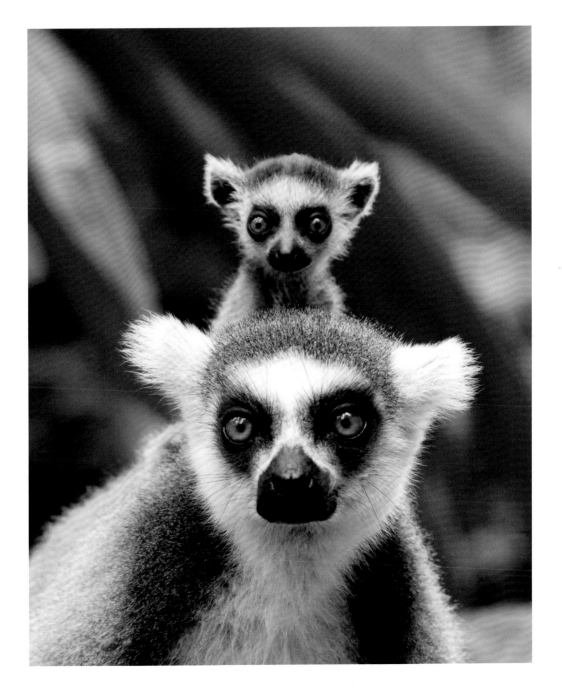

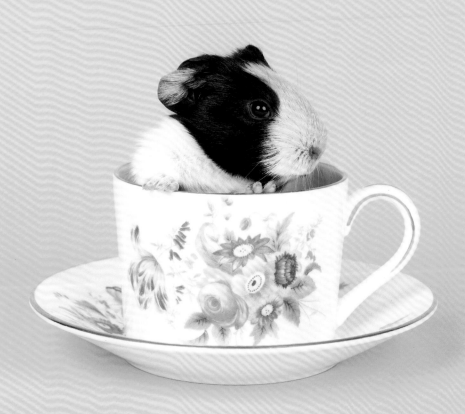

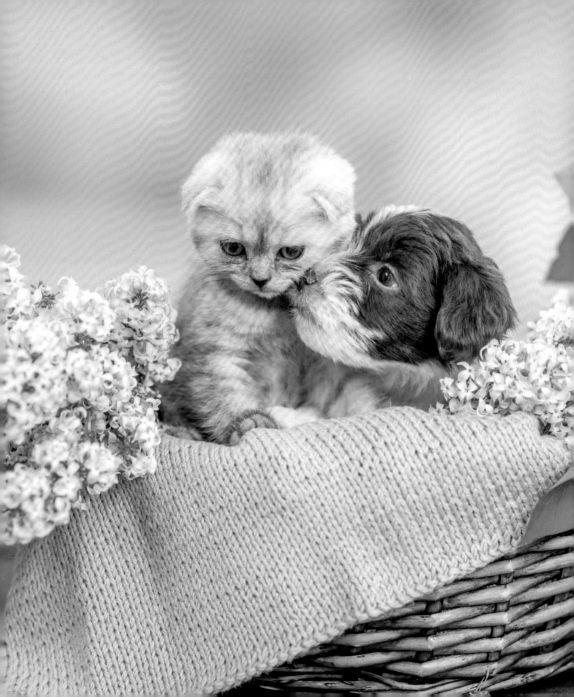

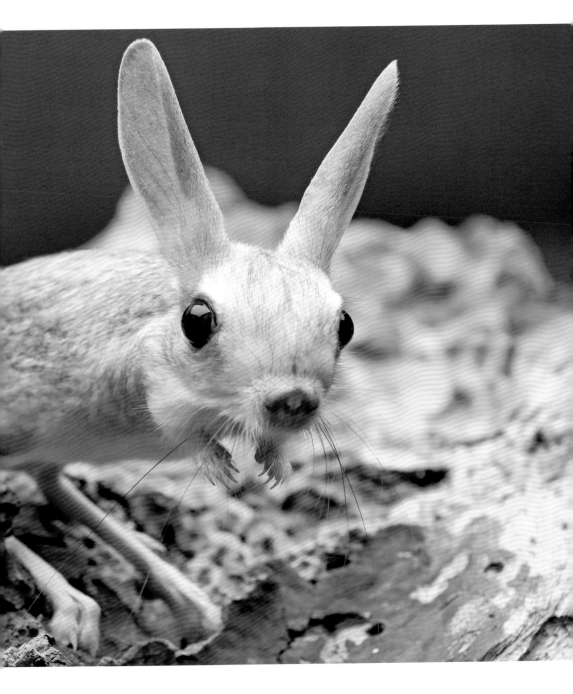

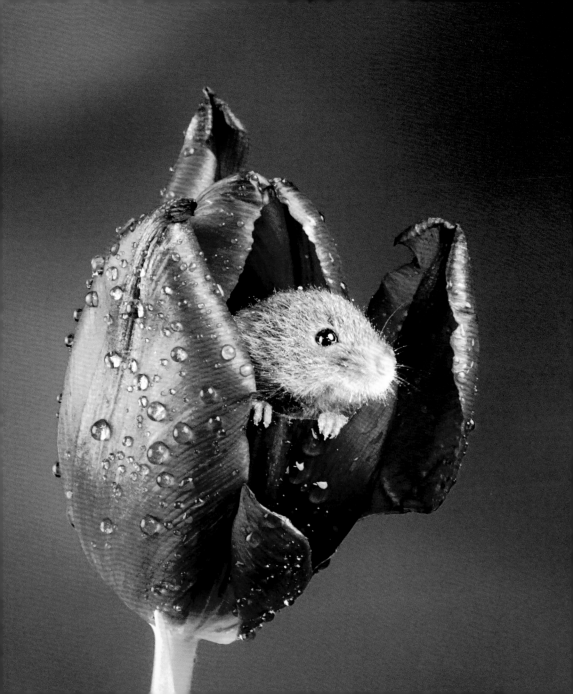

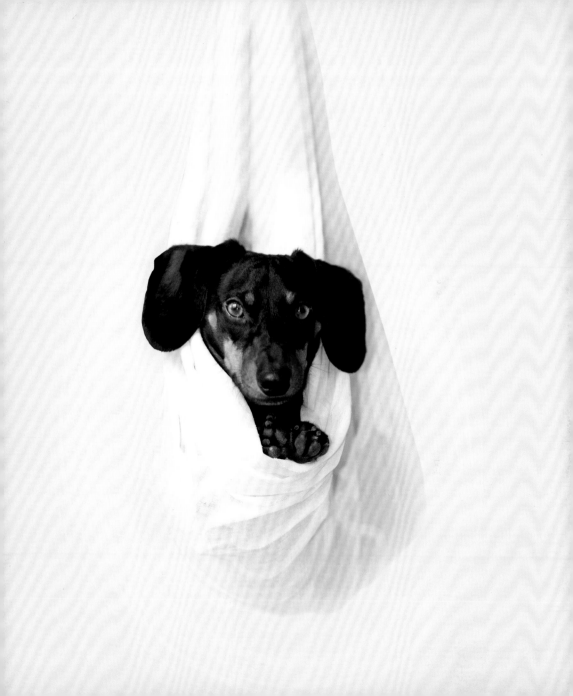

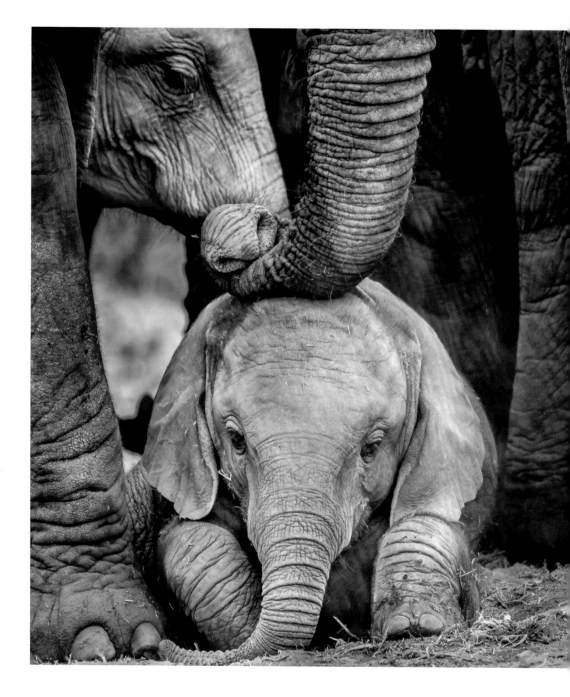

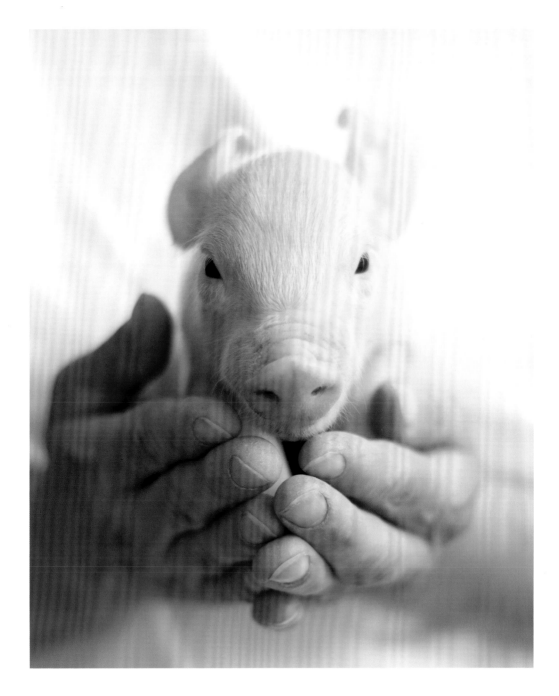

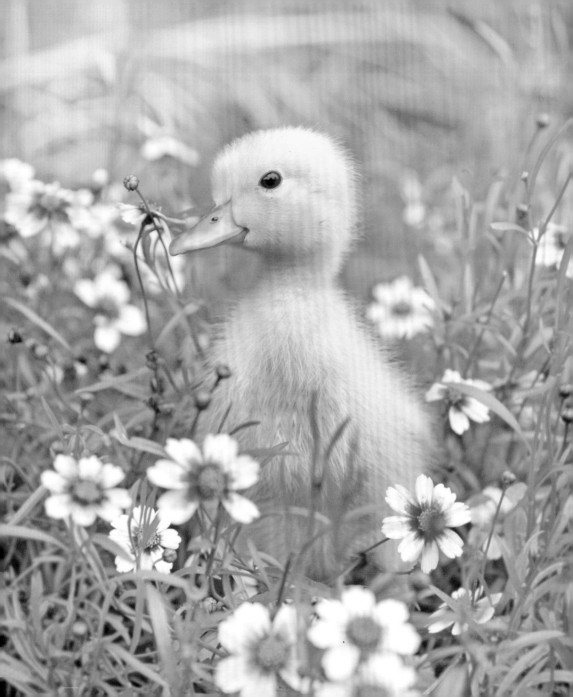

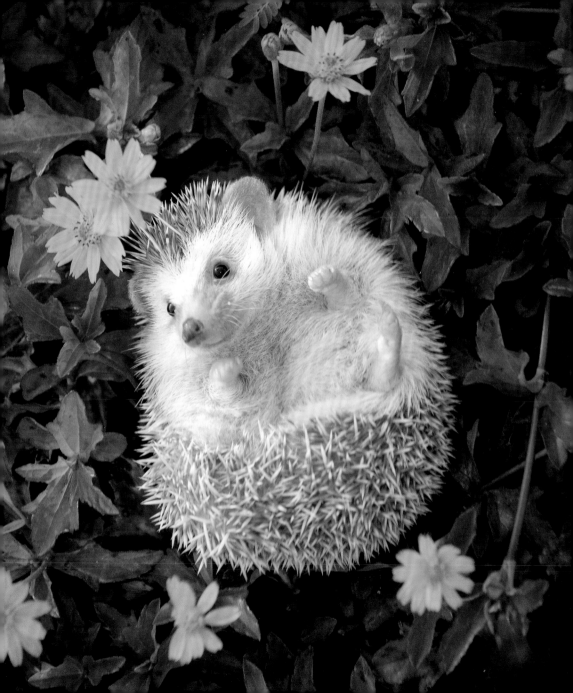

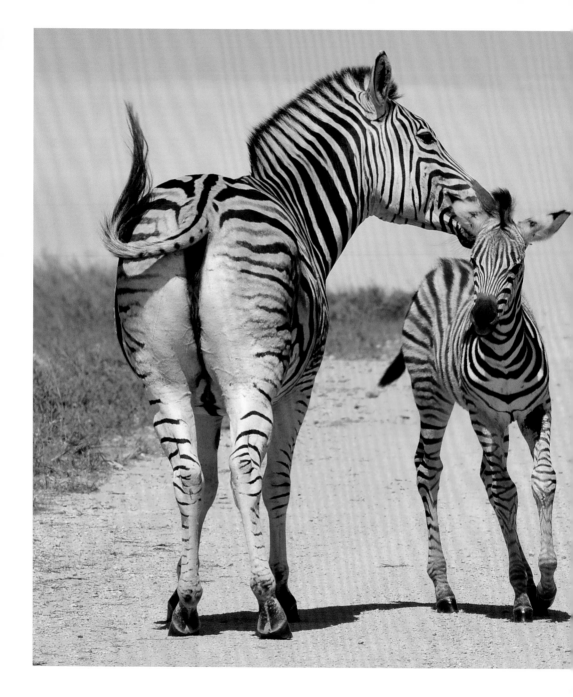

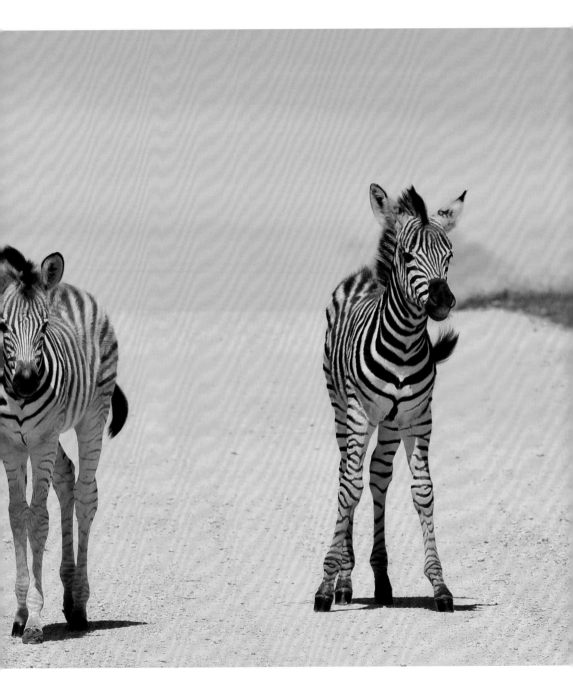

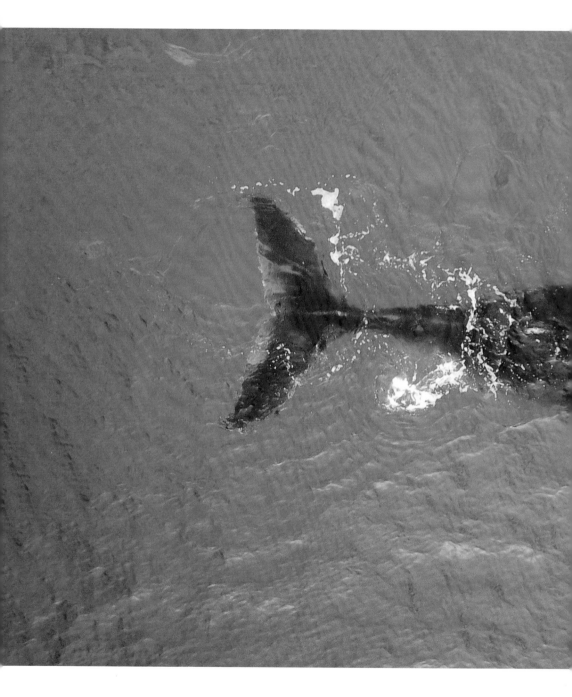

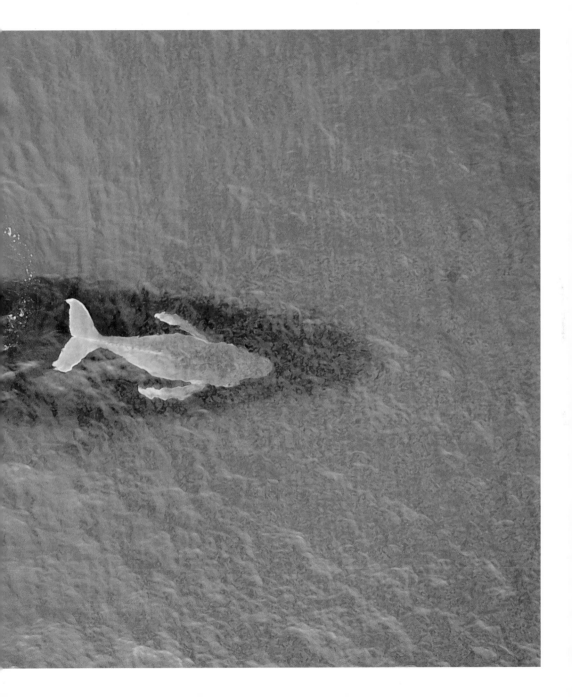

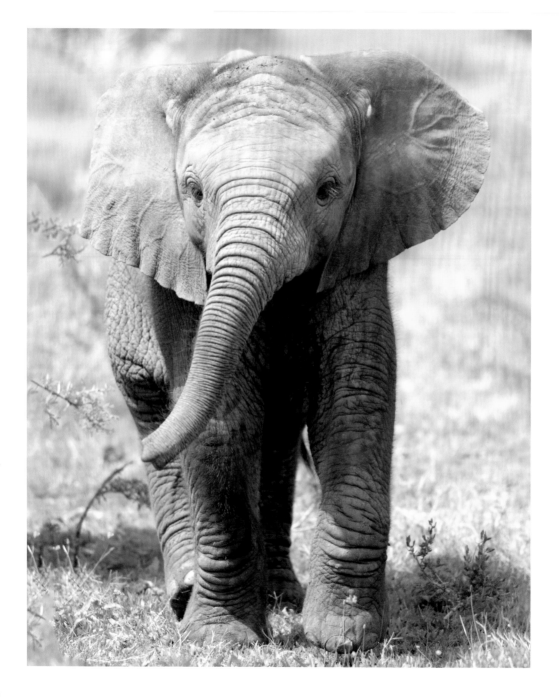

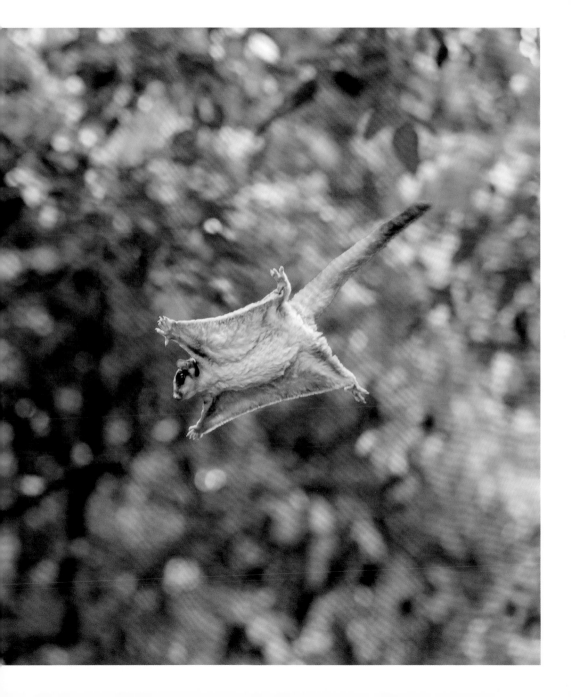

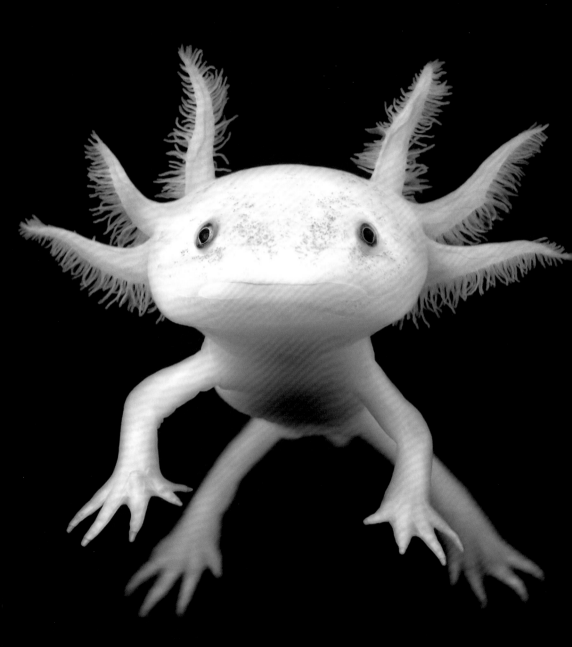

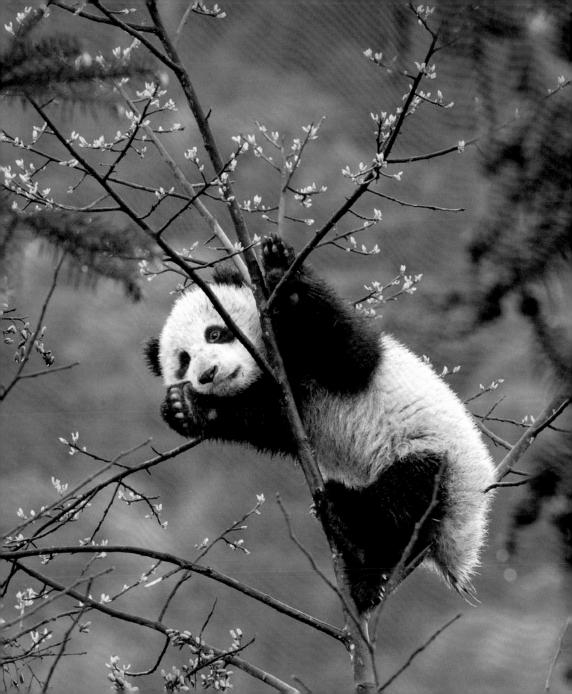

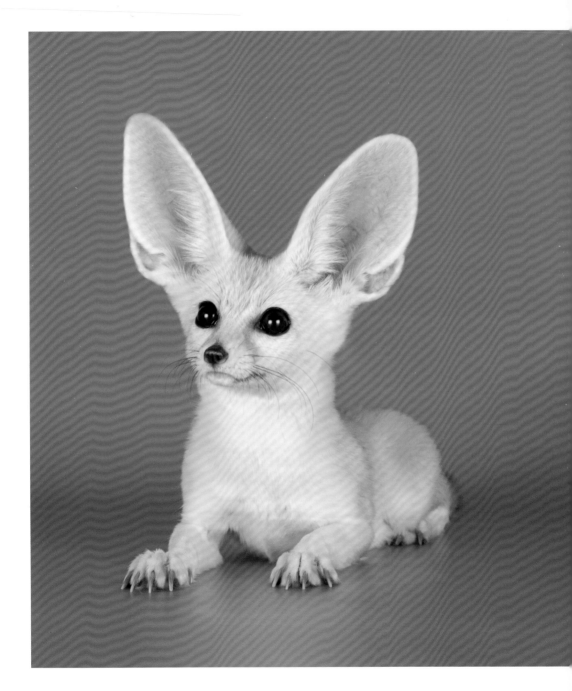

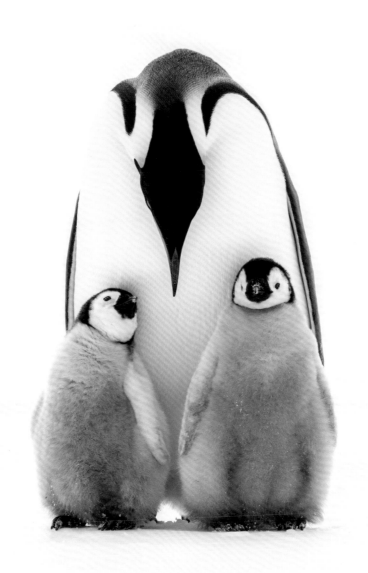

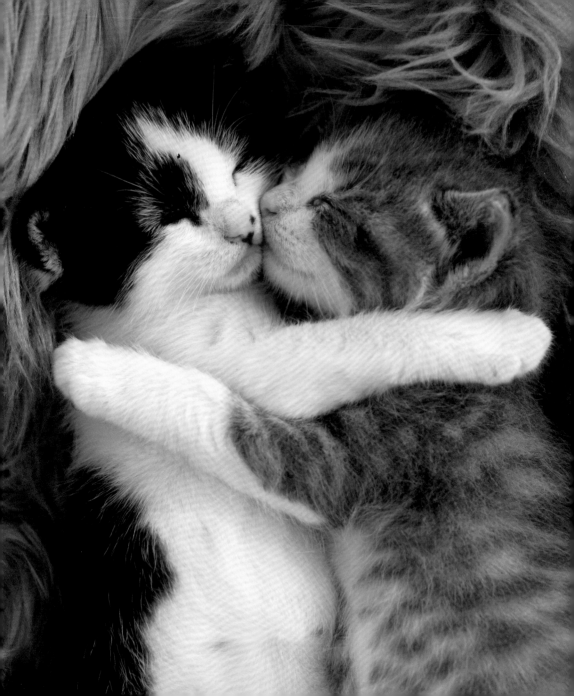

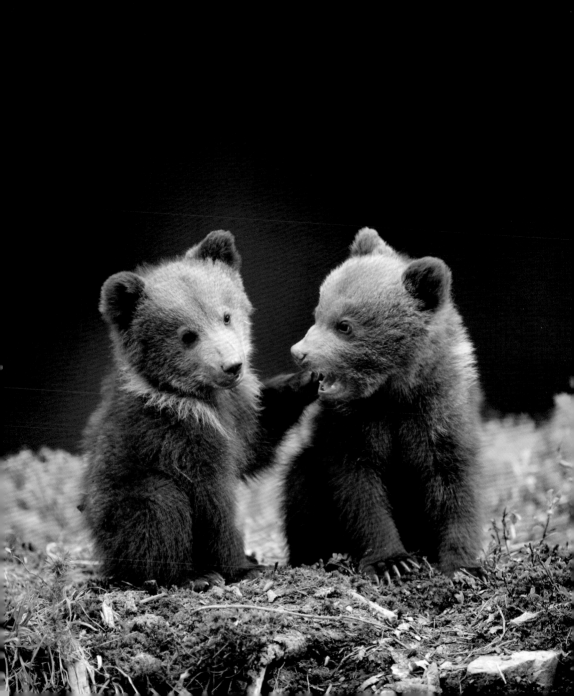

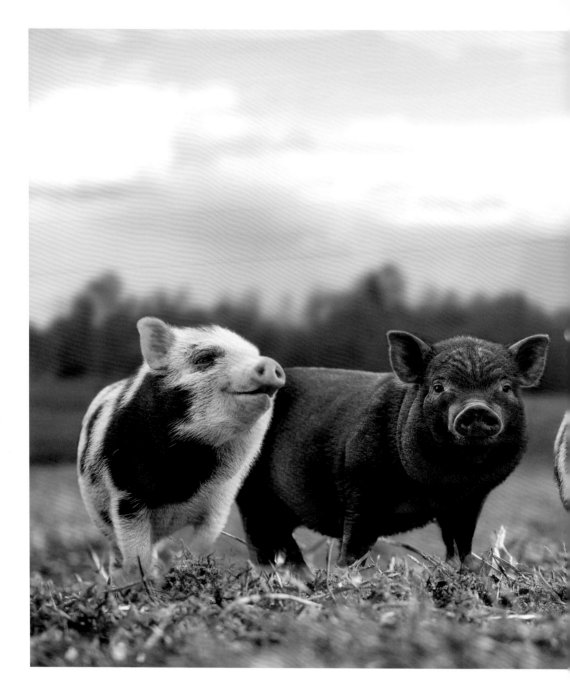

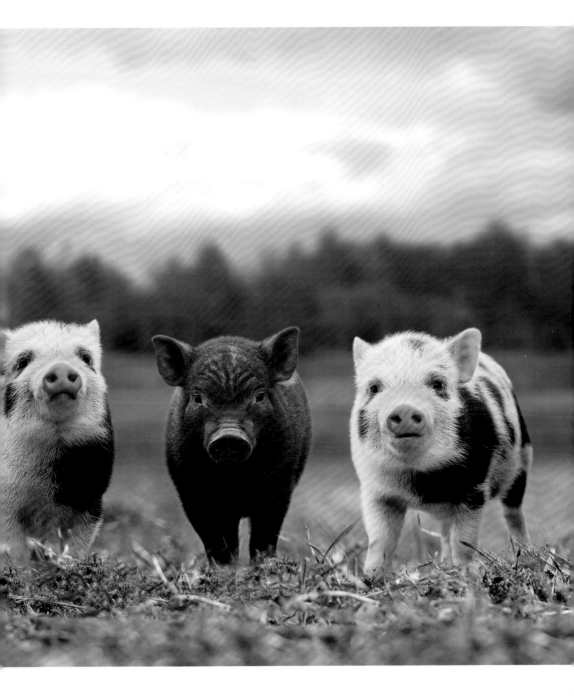

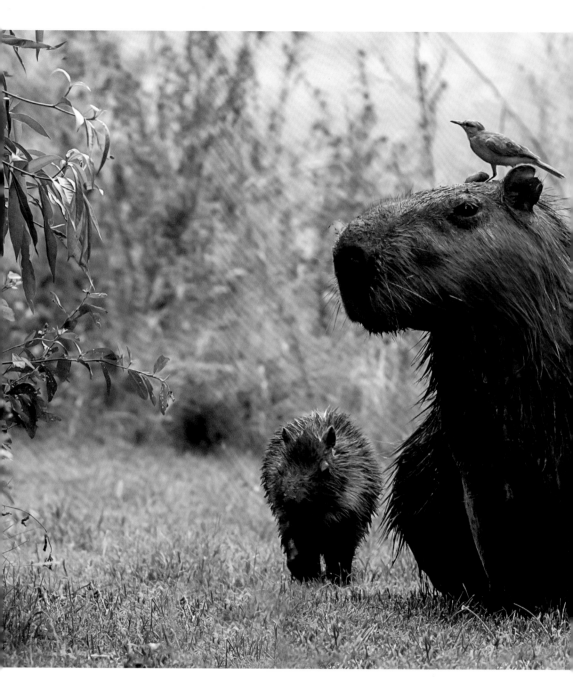

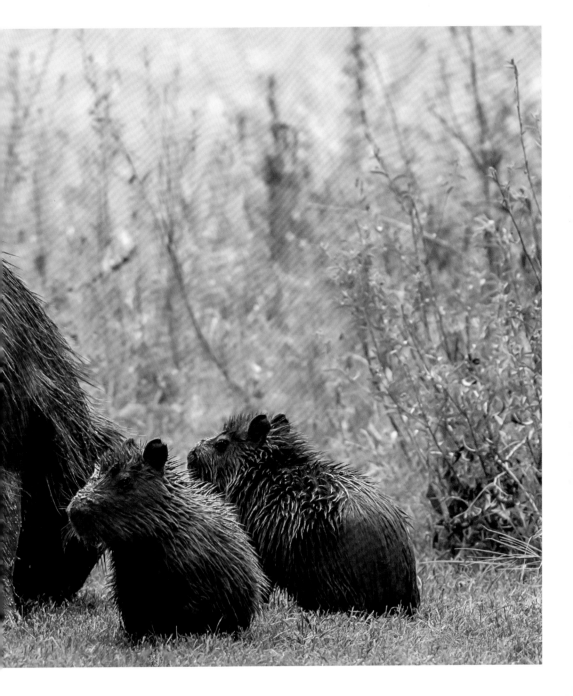

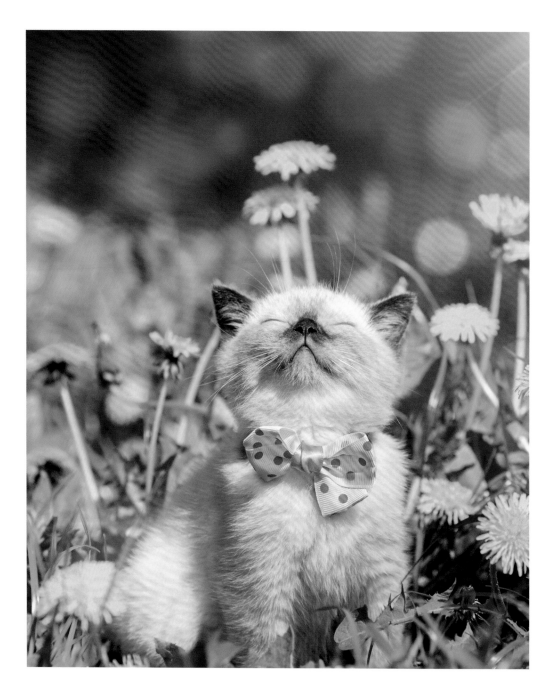

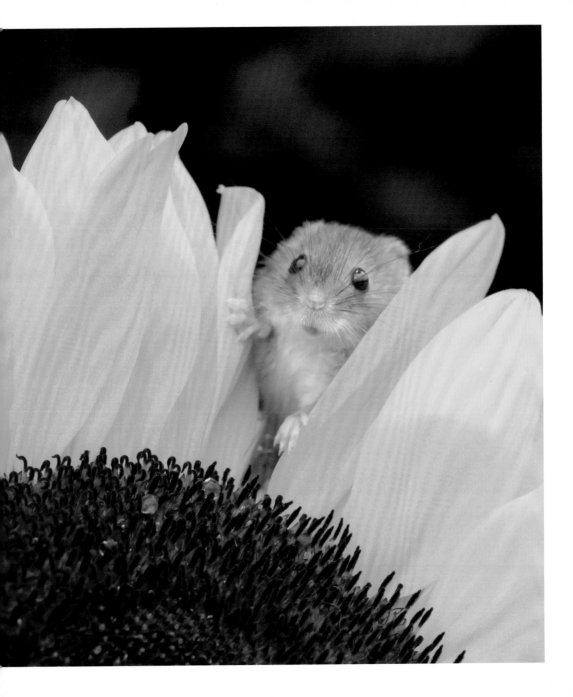

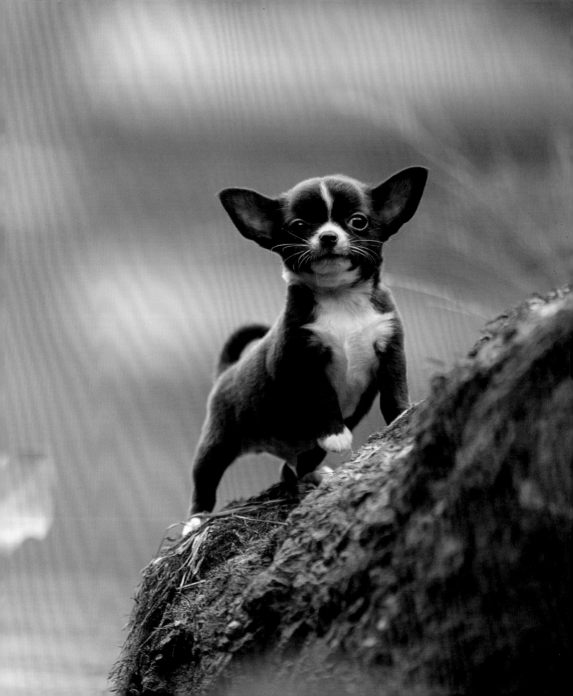

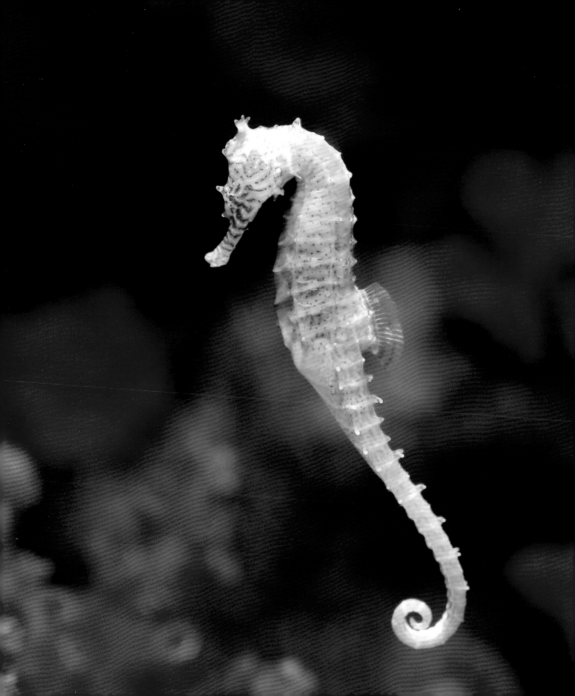

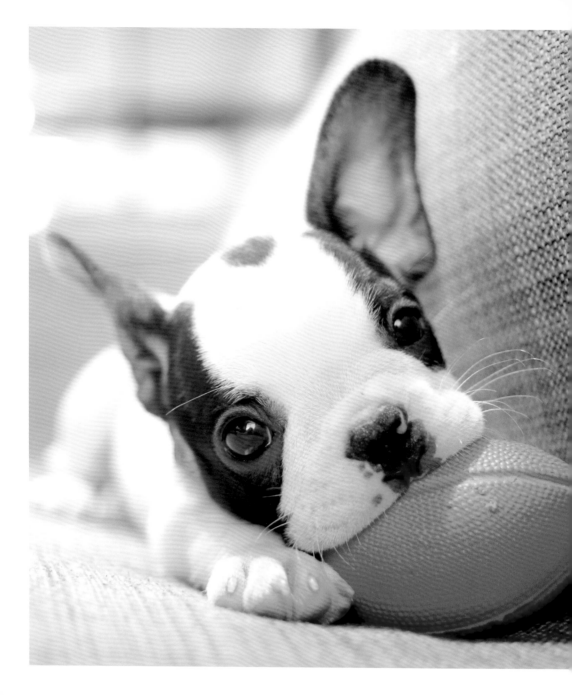

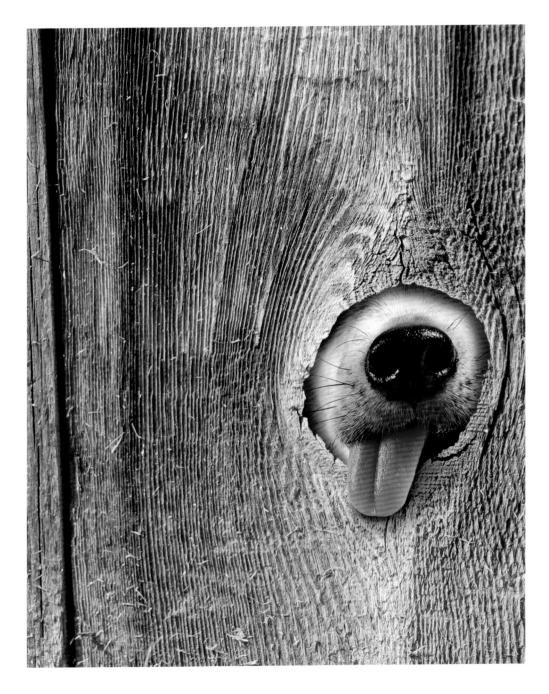

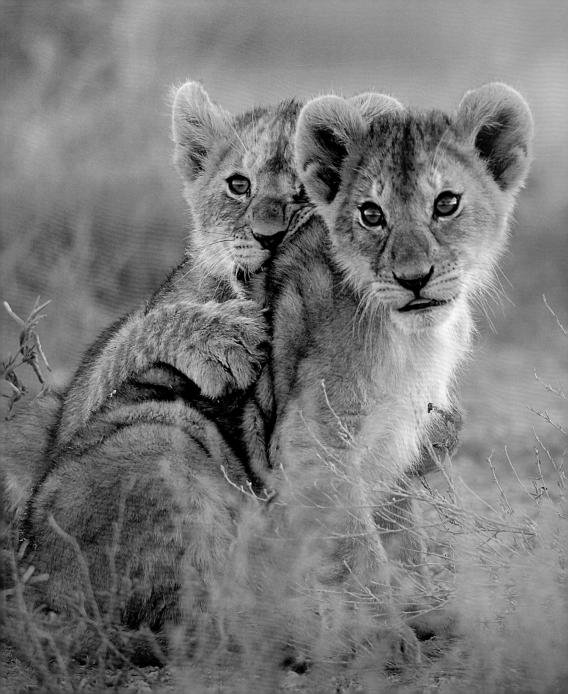

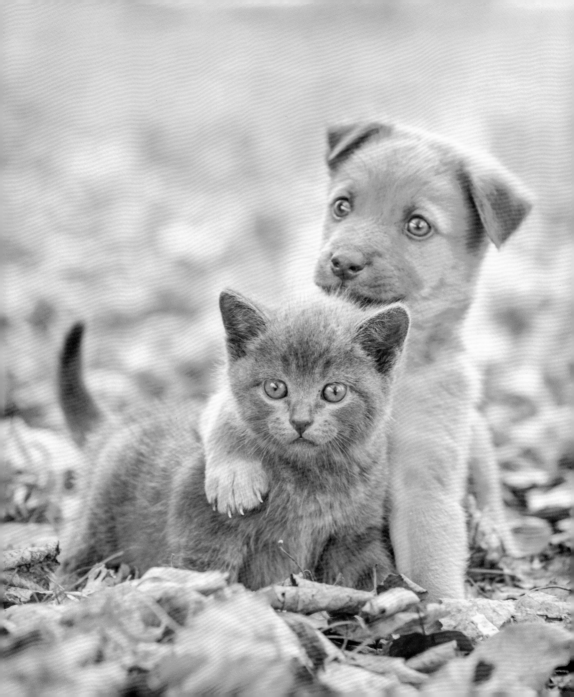

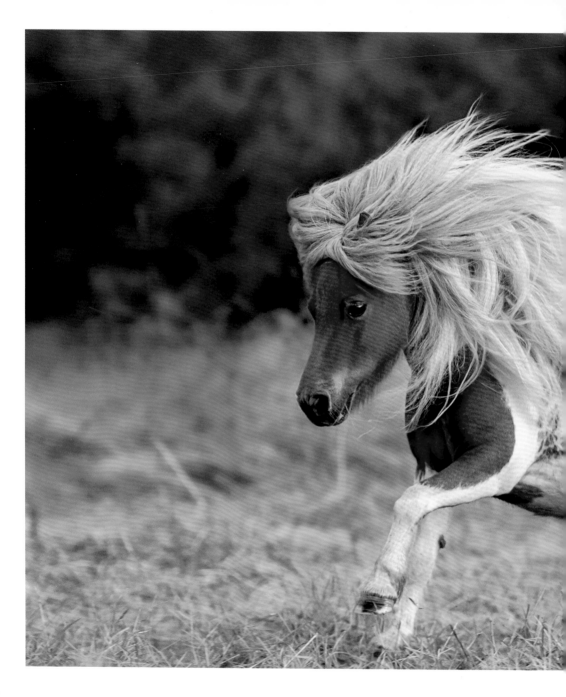

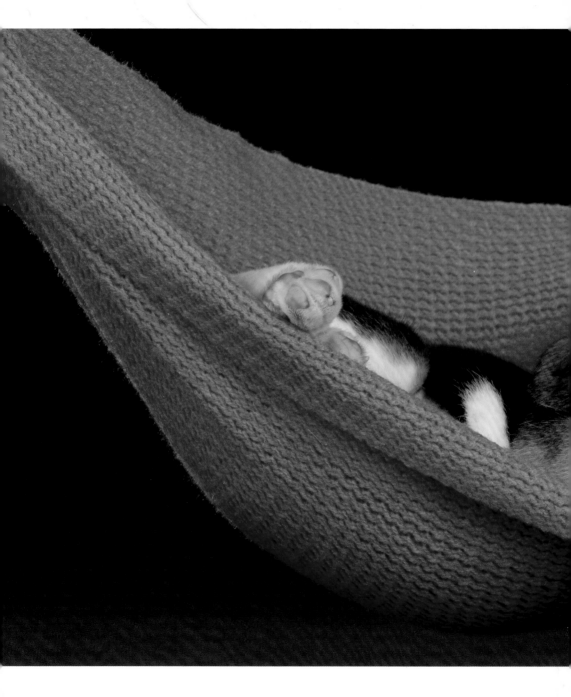

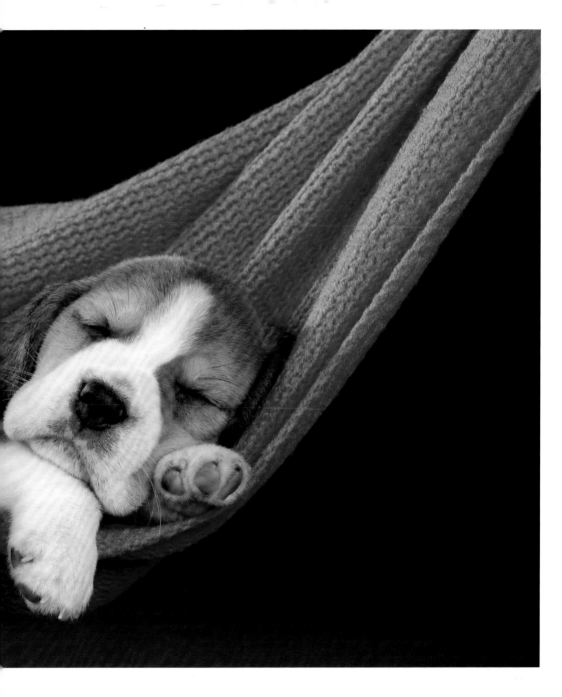

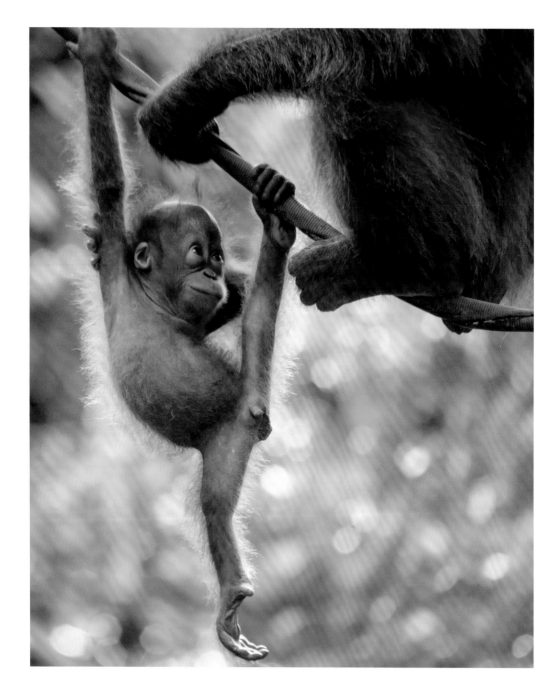

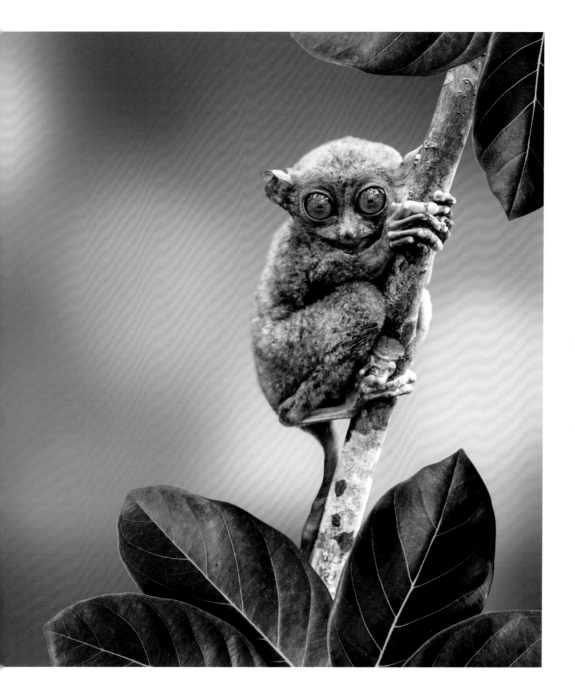

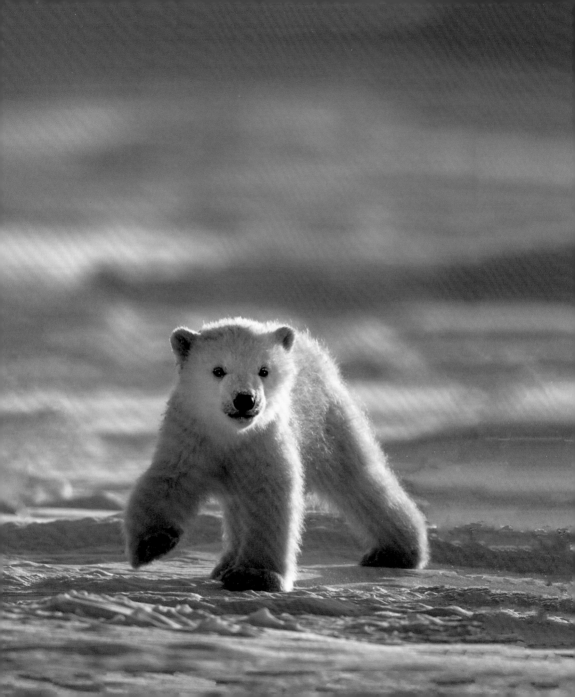

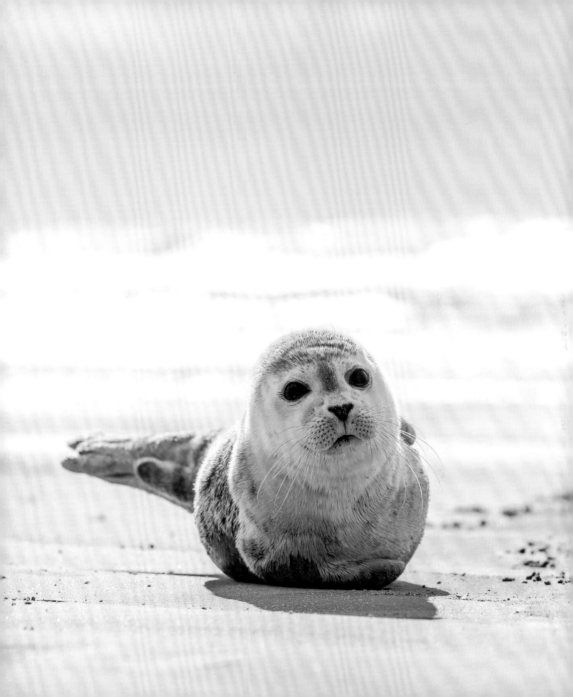

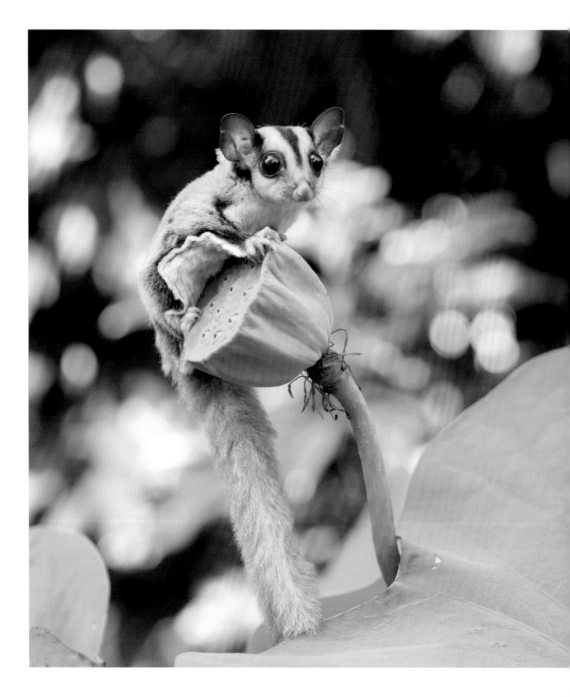

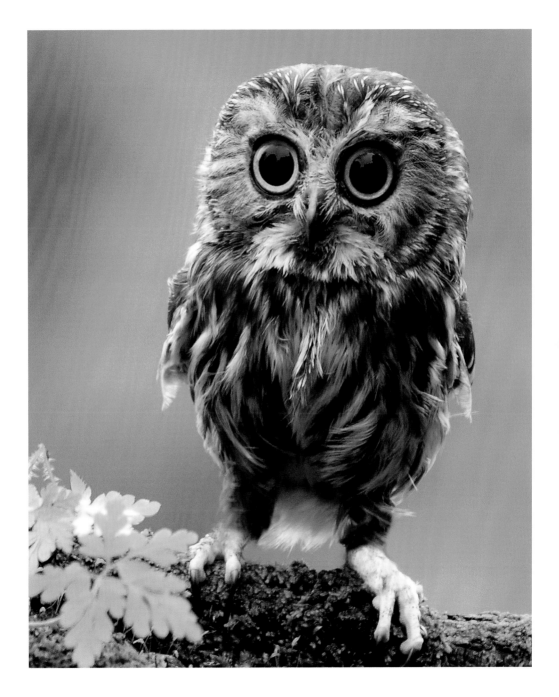

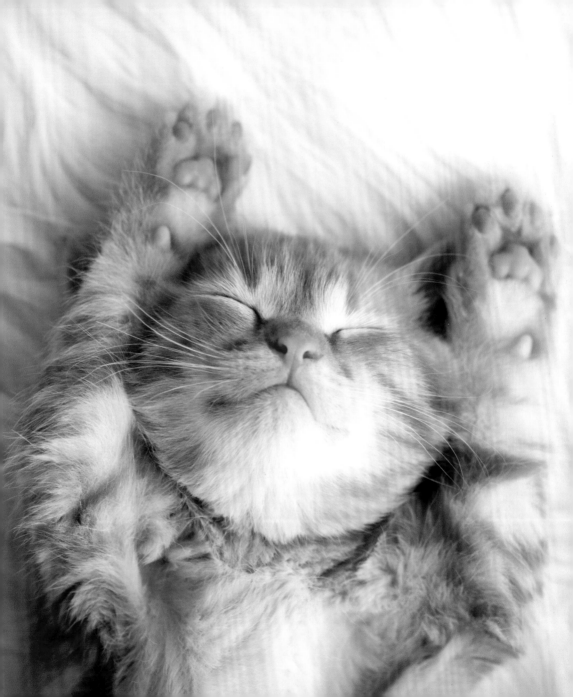

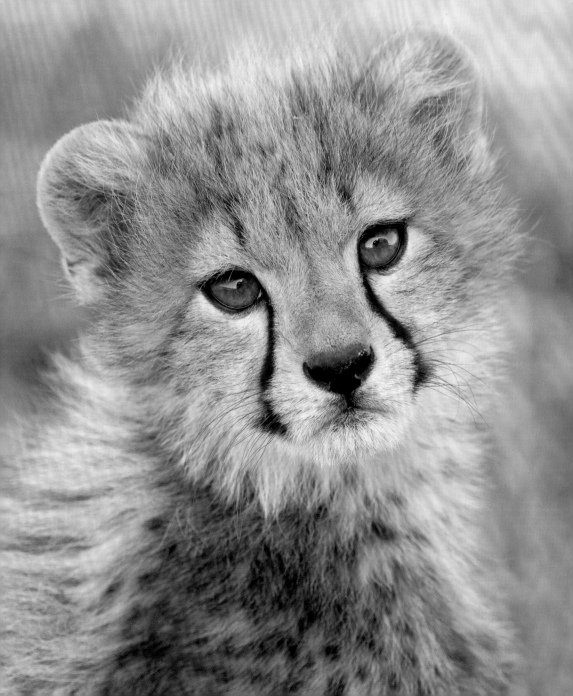

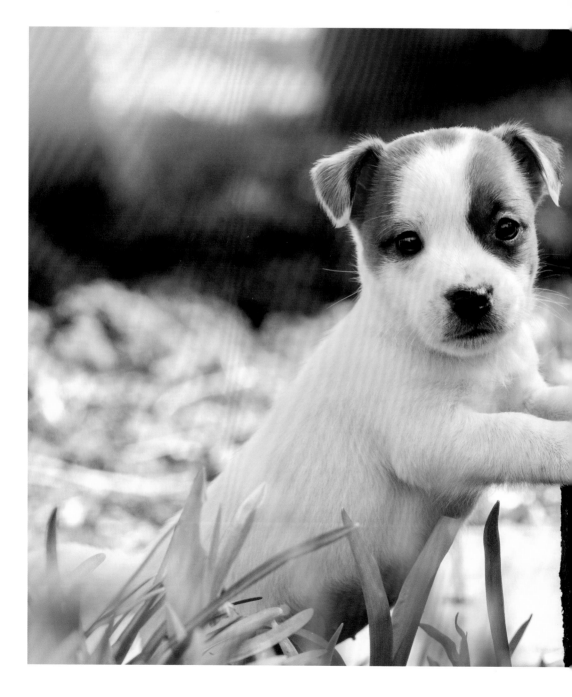

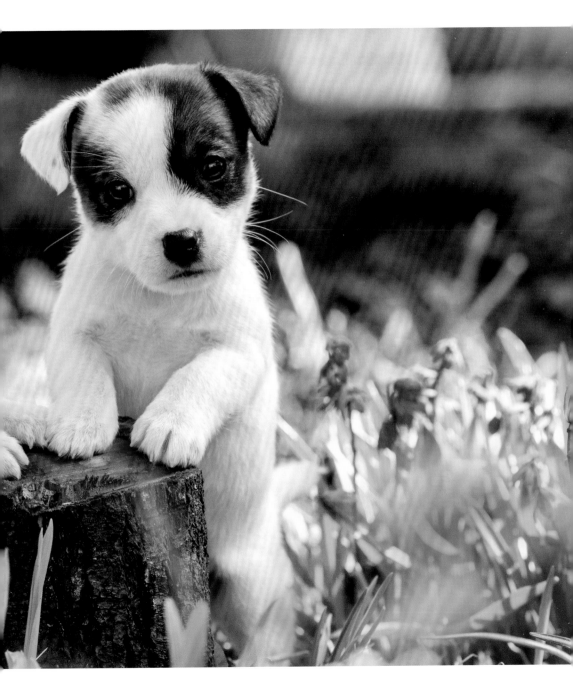

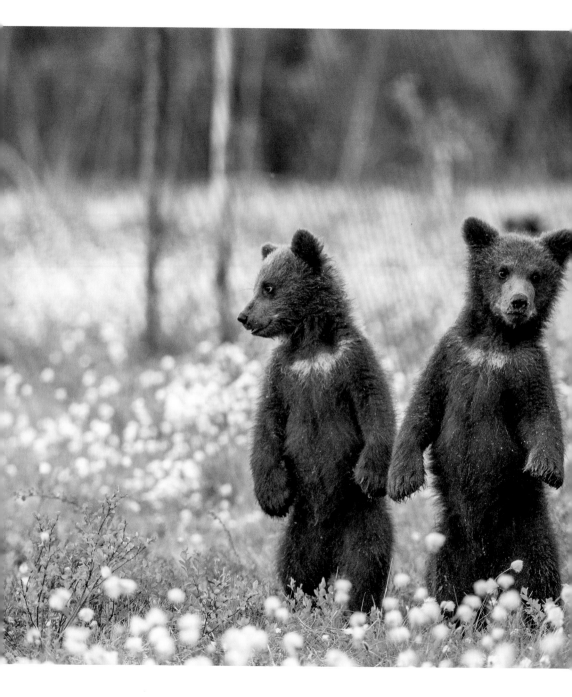

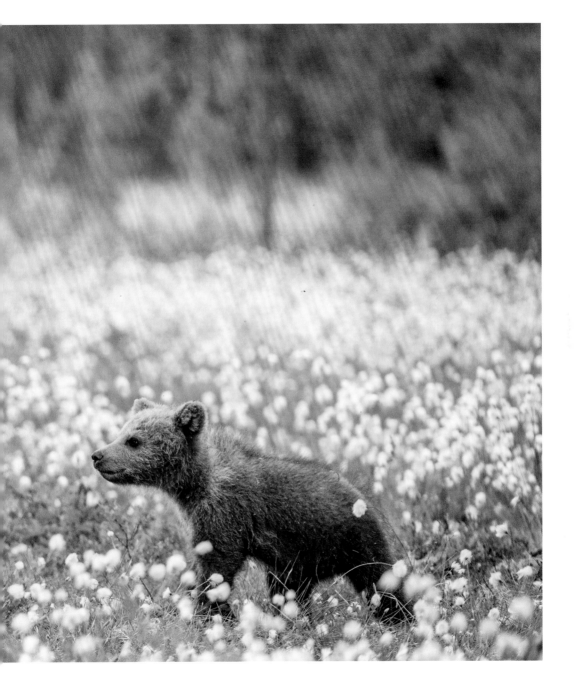

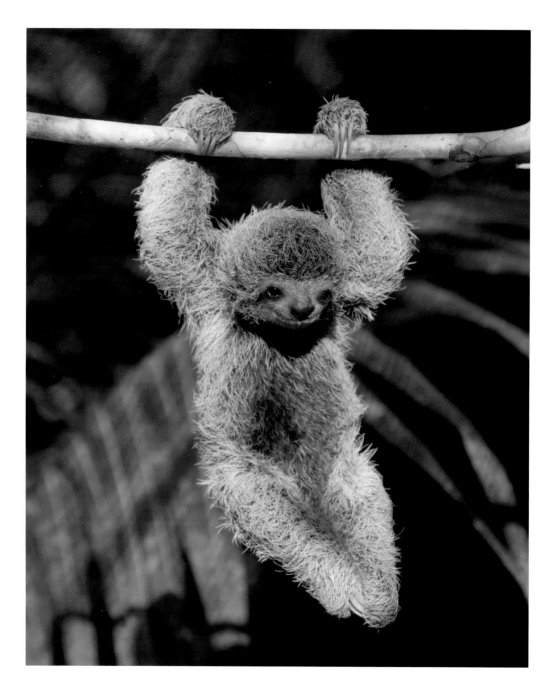

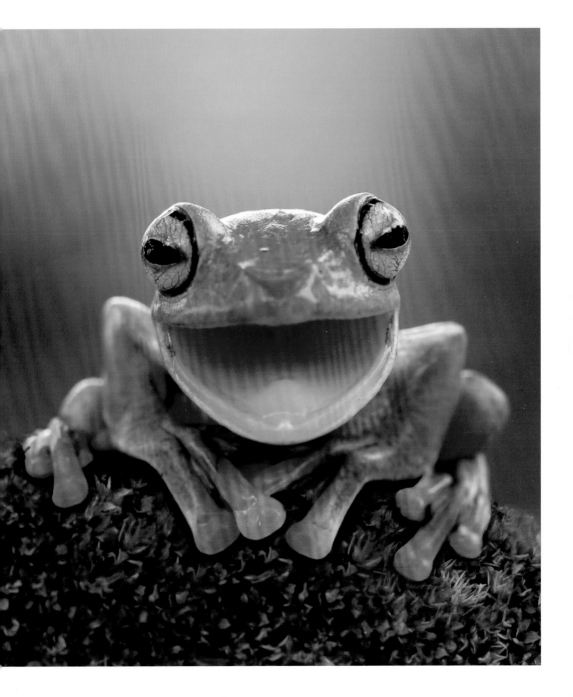

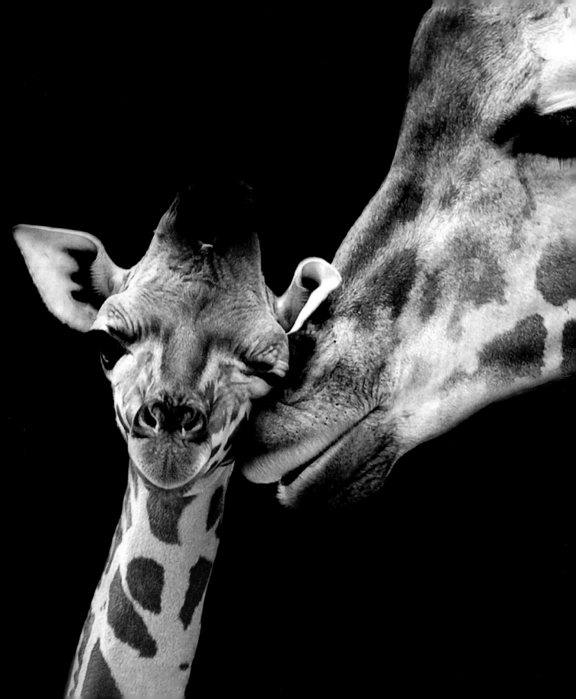

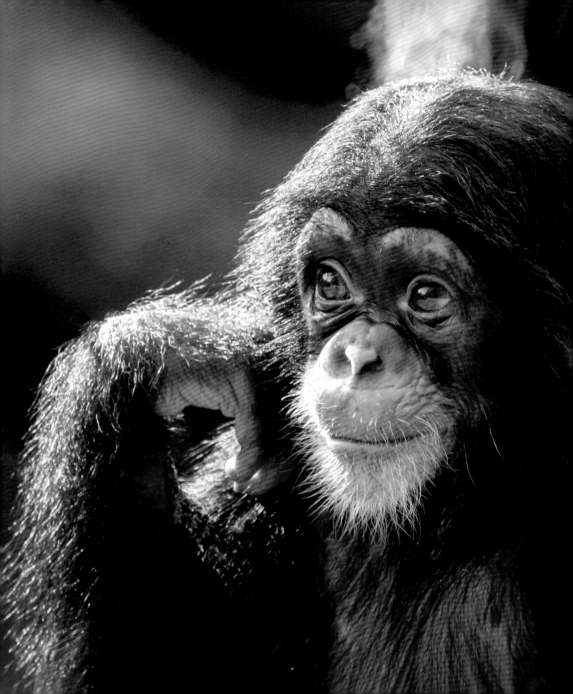

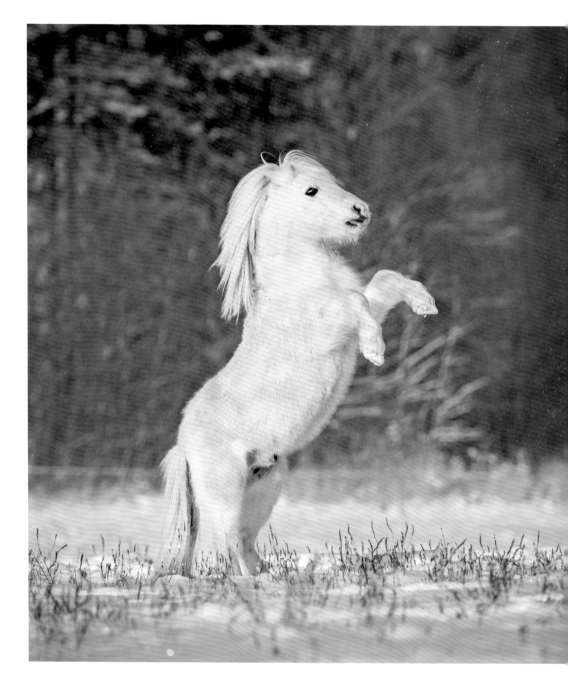

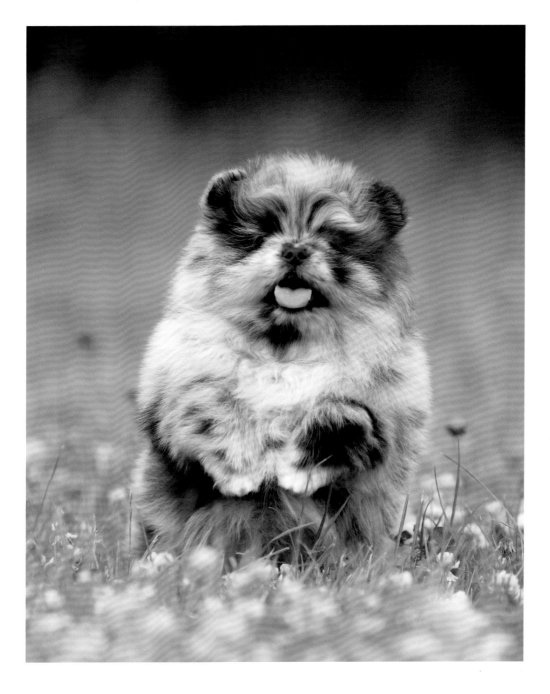

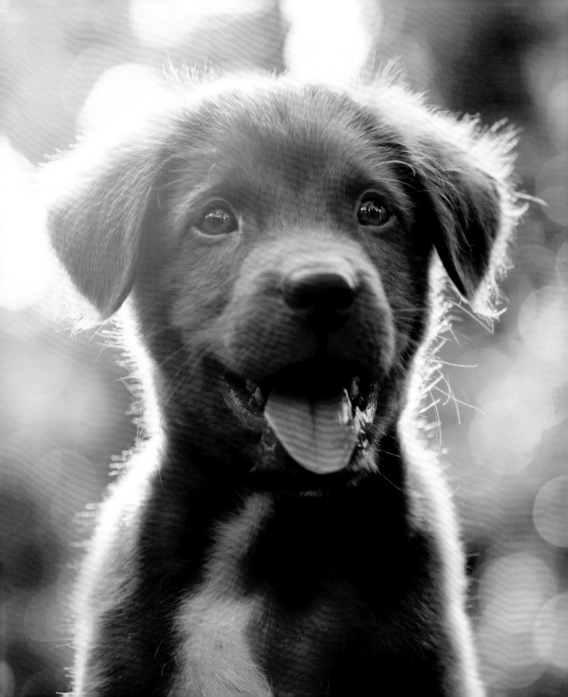

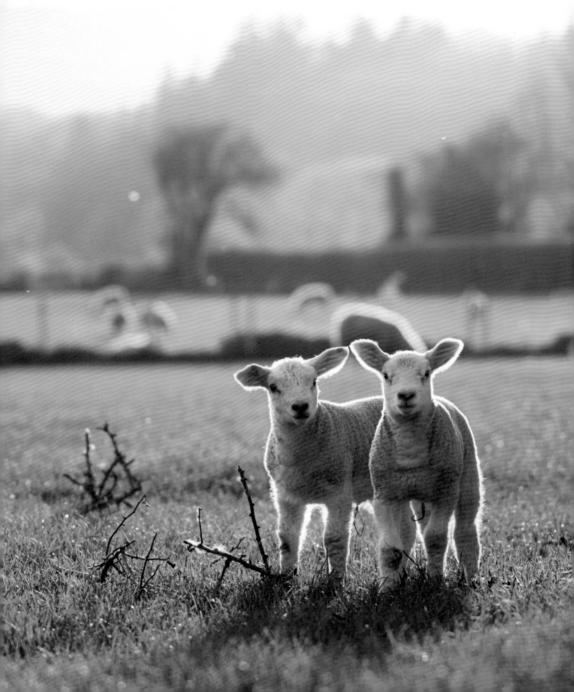

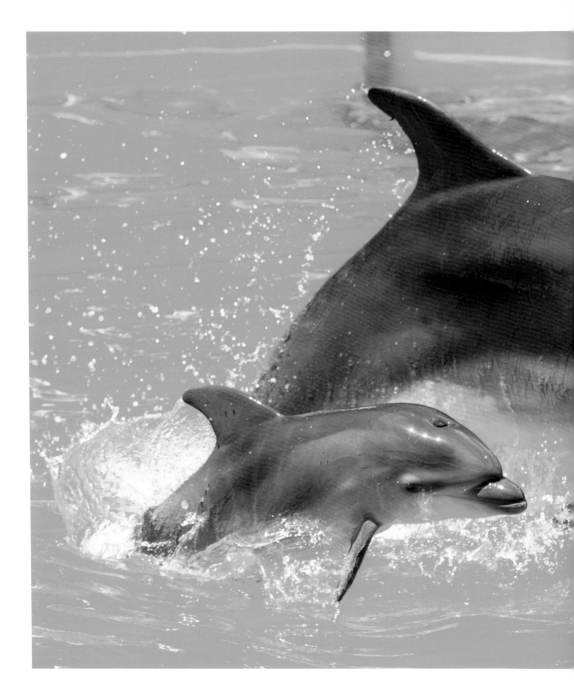

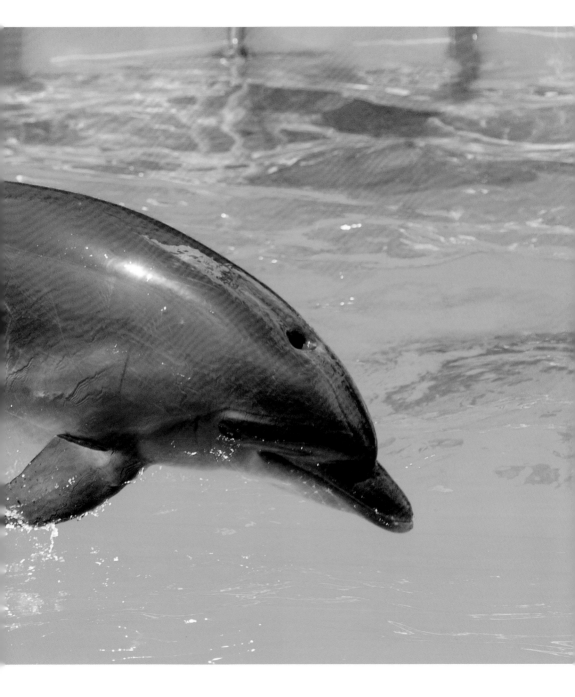

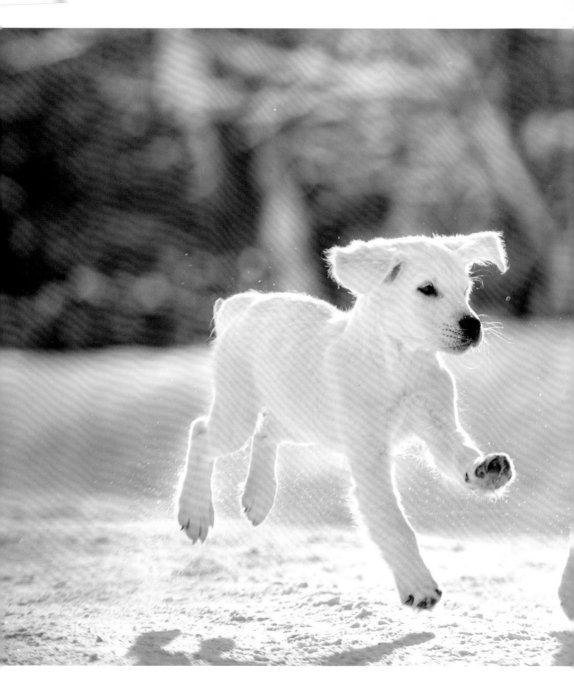

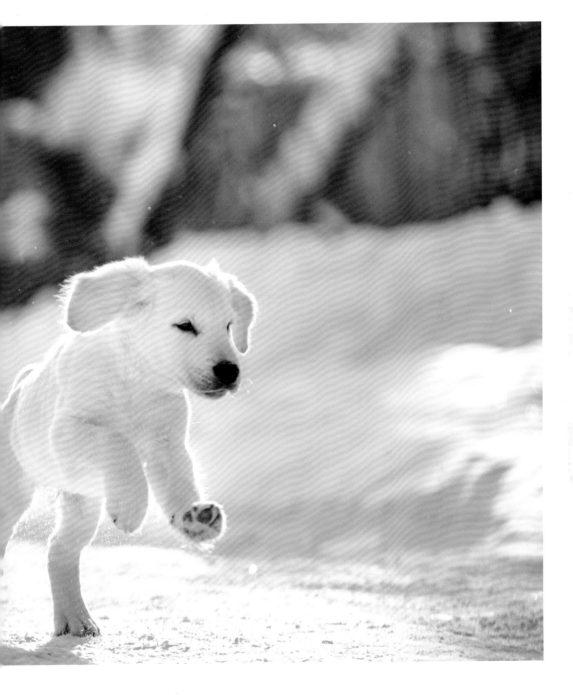

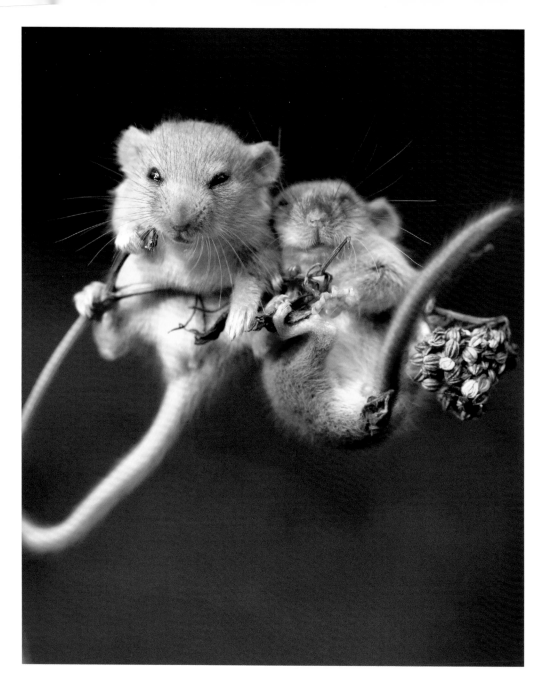

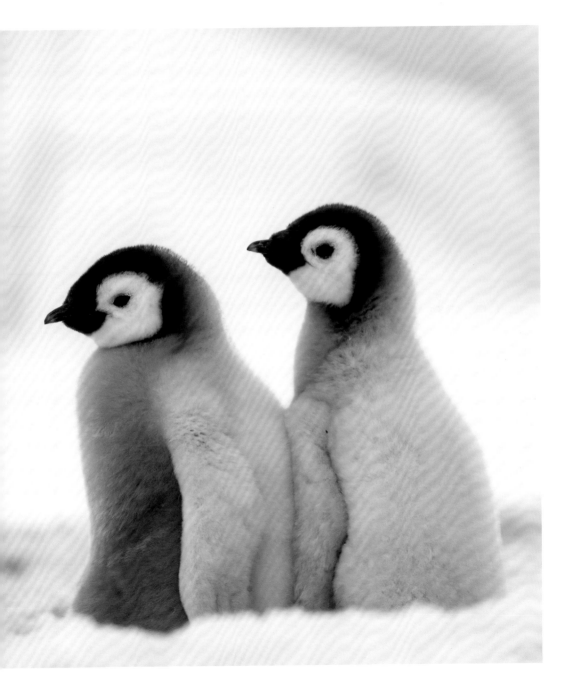

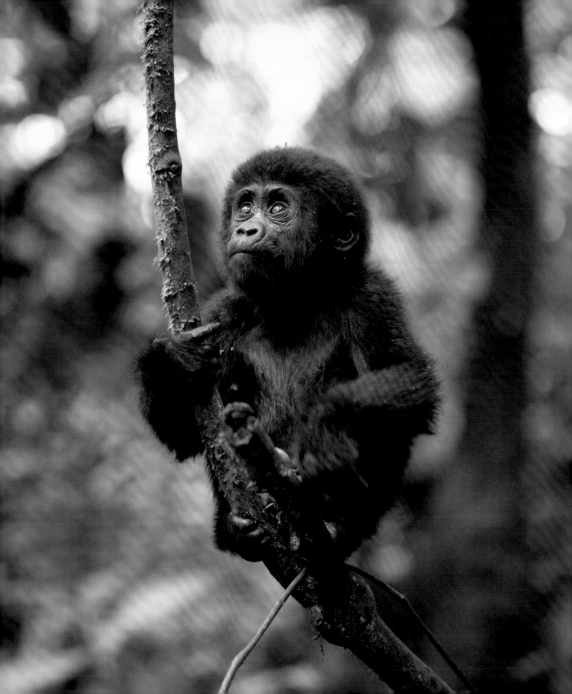

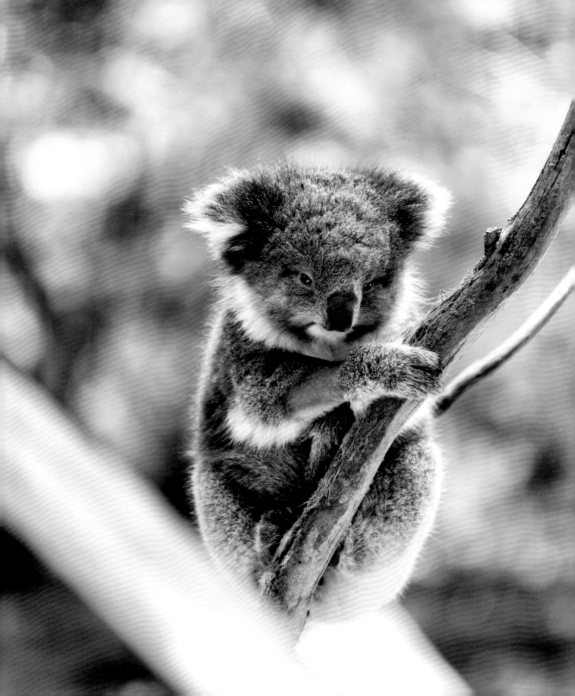

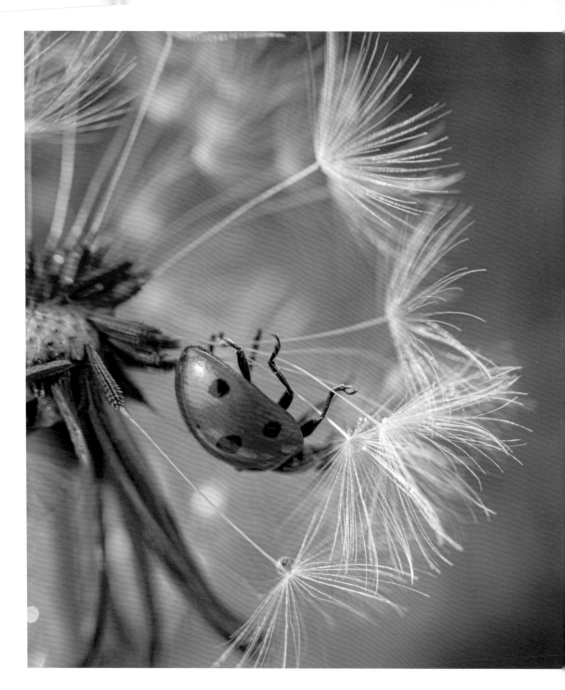

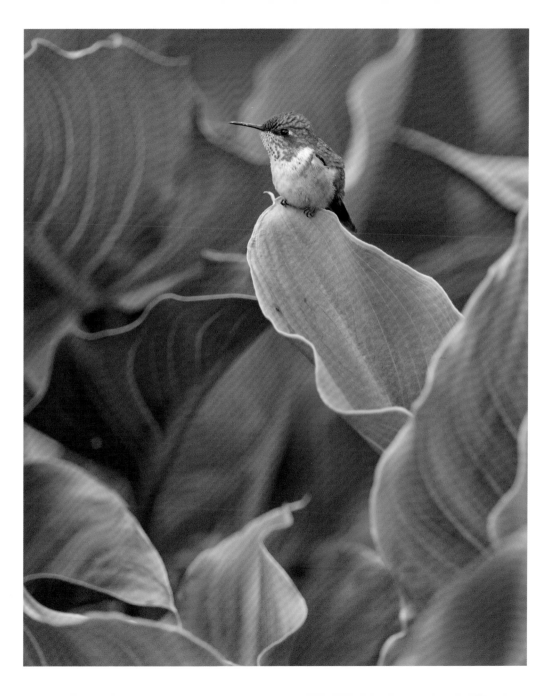

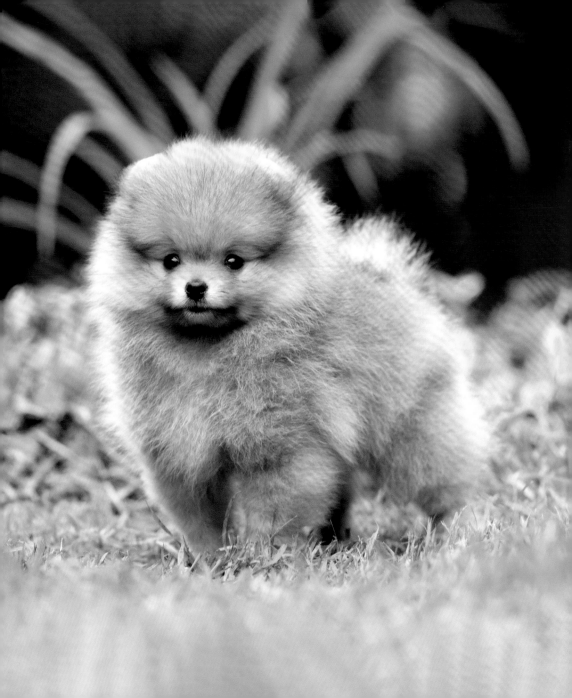

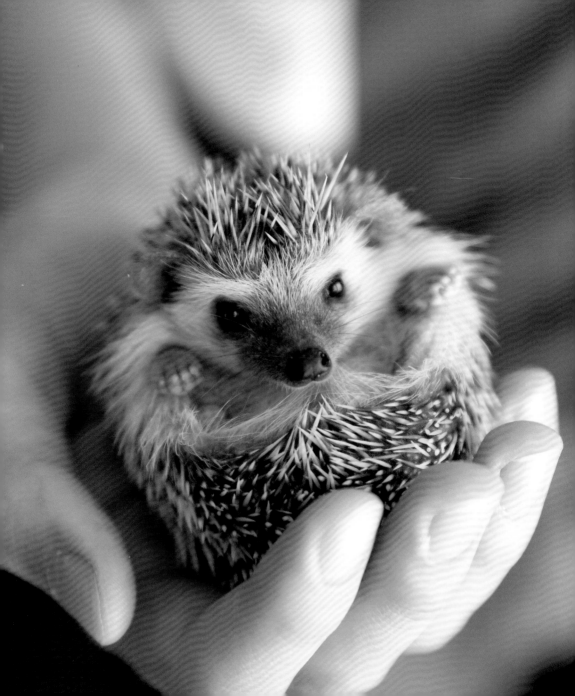

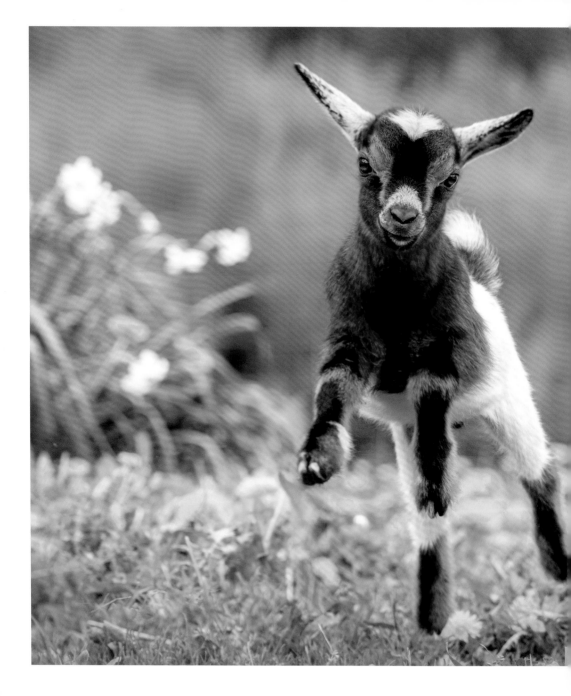

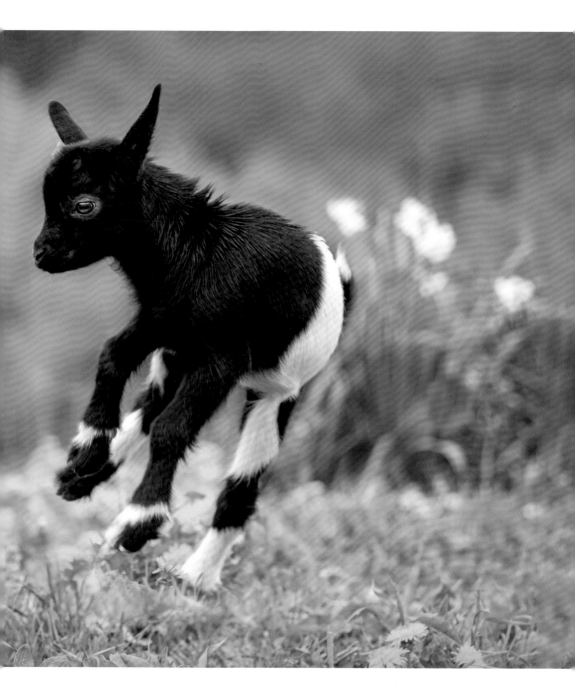

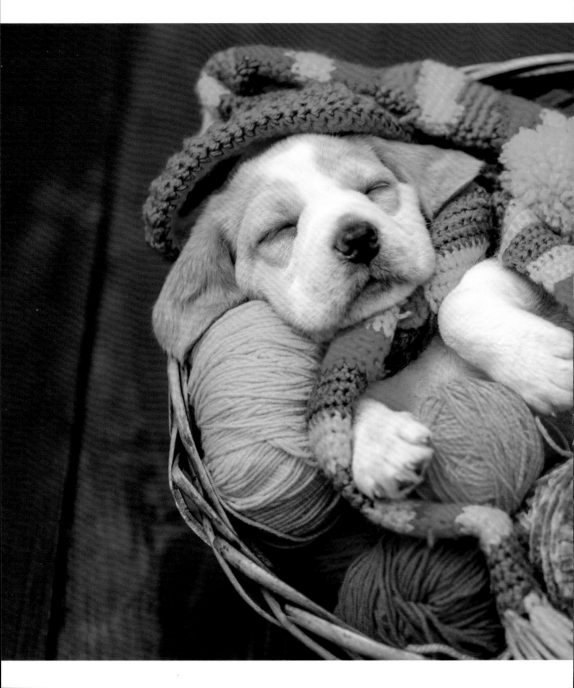

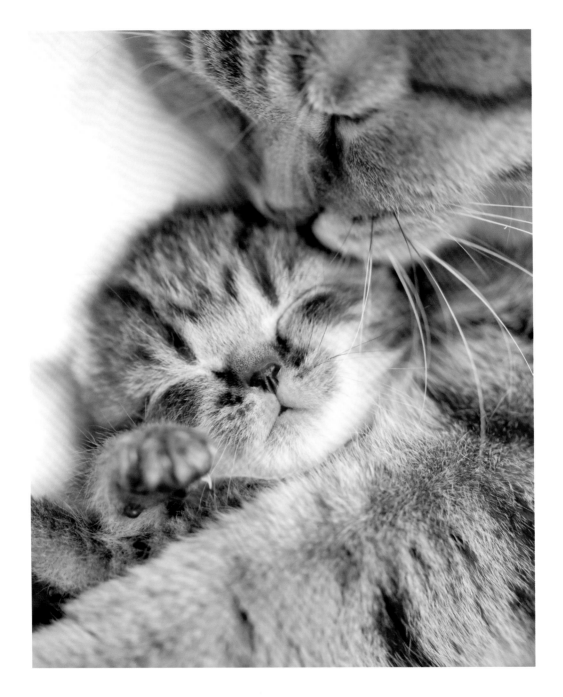

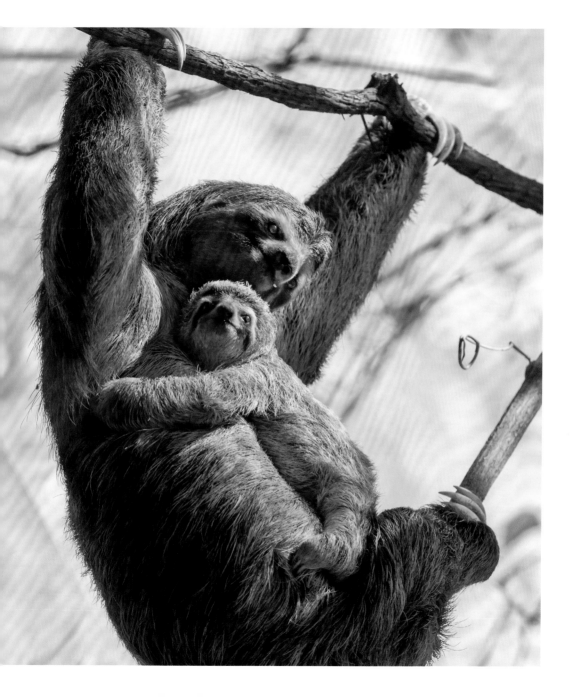

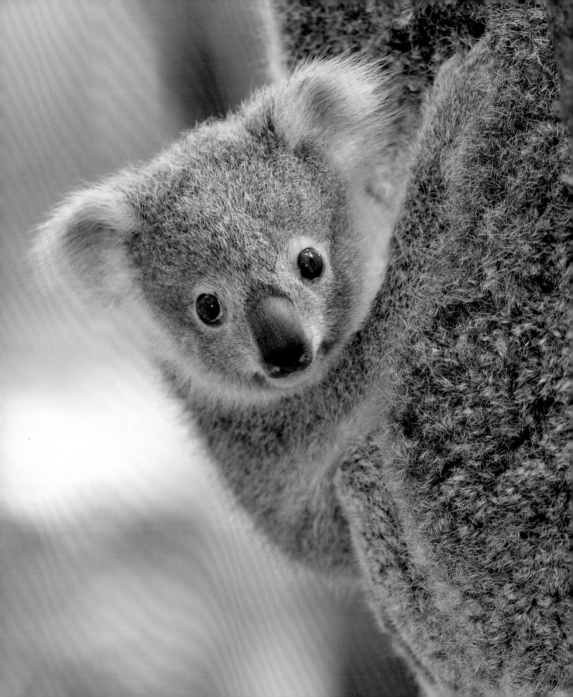

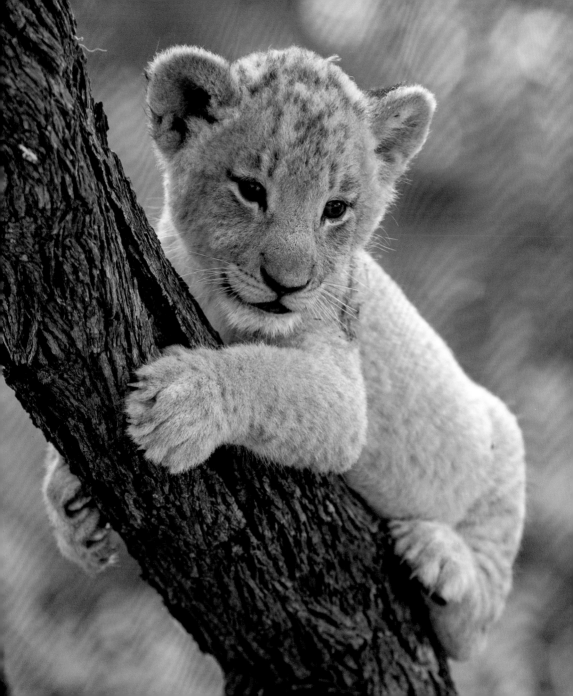

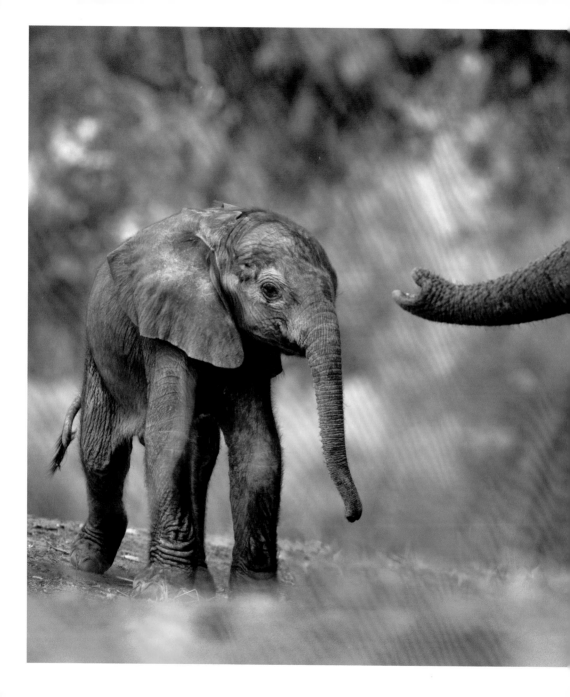

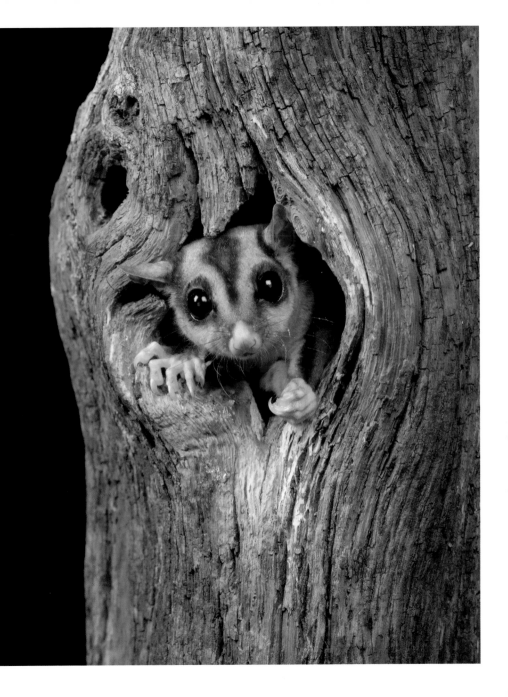

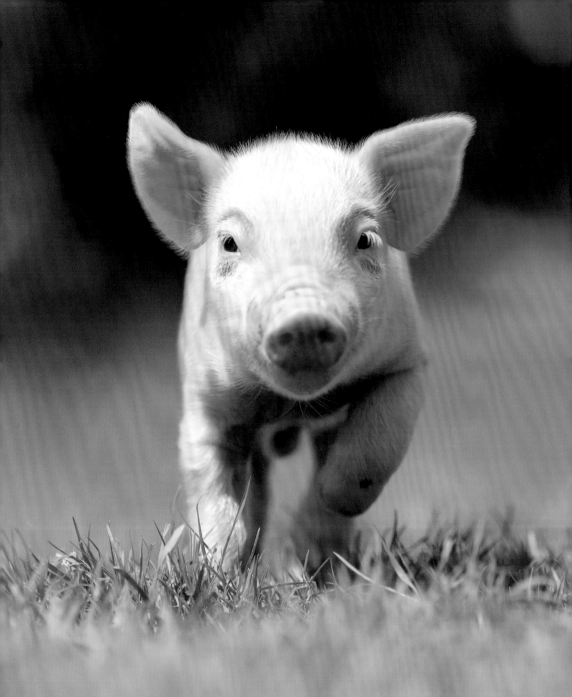

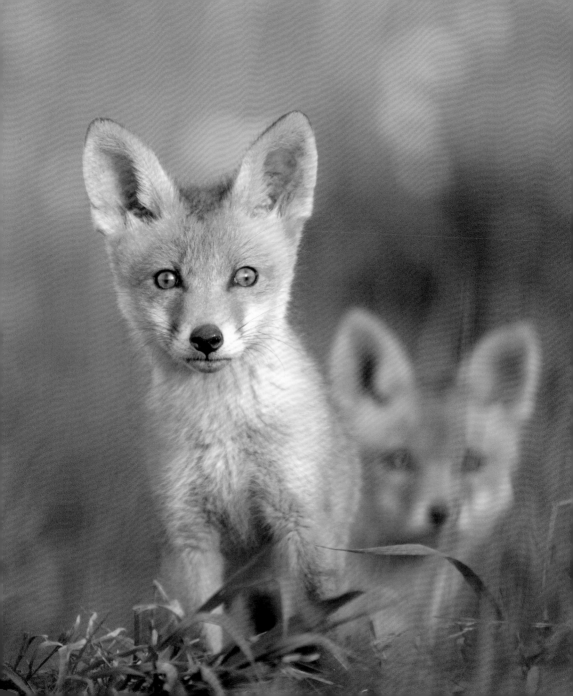

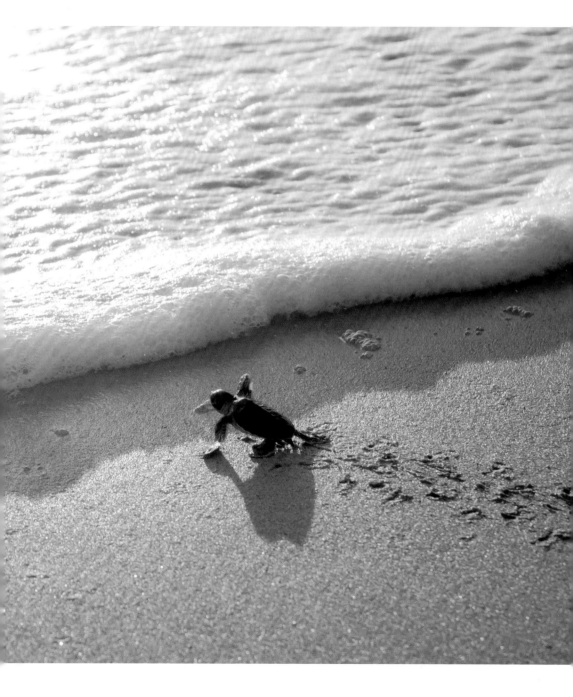

Smith Street Books

Published in 2023 by Smith Street Books
Naarm (Melbourne) | Australia
smithstreetbooks.com

ISBN: 978-1-9227-5457-8

Smith Street Books respectfully acknowledges the Wurundjeri People of the Kulin Nation, who are the Traditional Owners of the land on which we work, and we pay our respects to their Elders past and present.

Publisher: Paul McNally
Design and layout: Hannah Koelmeyer
Cover photo: Ian Ross Pettigrew/Getty Images

Printed & bound in China by C&C Offset Printing Co., Ltd.

Book 284
10 9 8 7 6 5 4 3 2 1

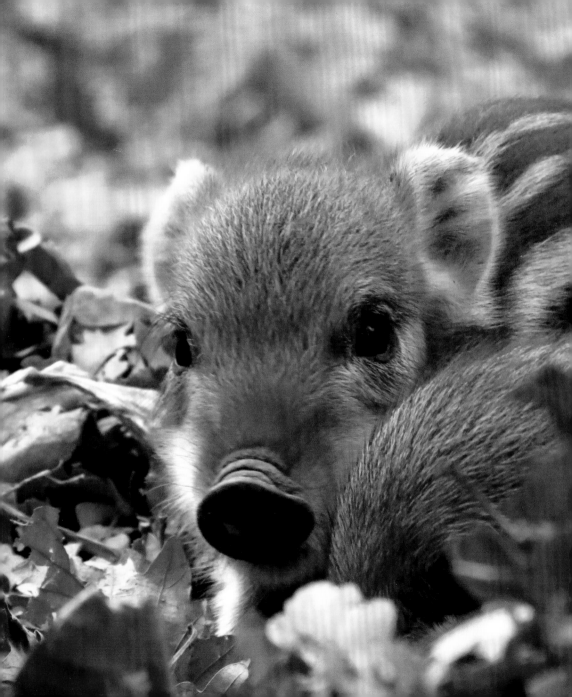